KIRIGAMI

GREETING CARDS AND GIFT WRAP

Florence Temko

TUTTLE PUBLISHING

Boston • Rutland, Vermont • Tokyo

First published in 2004 by Tuttle Publishing, an imprint of Periplus Editions (HK) Ltd., with editorial offices at 153 Milk Street, Boston, Massachusetts 02109.

Temko, Florence.
 Kirigami greeting cards and gift wrap / Florence Temko.— 1st ed.
 p. cm.
 ISBN 0-8048-3606-X (pbk.)
 1. Paper work. 2. Cut-out craft. 3. Greeting cards. 4. Gift
wrapping. I. Title. TT870.T4453 2004
 745.594'1—dc22
 2004007242

Distributed by

North America, Latin America & Europe
Tuttle Publishing
Distribution Center
Airport Business Park
364 Innovation Drive
North Clarendon, VT 05759-9436
Tel: (802) 773-8930
Fax: (802) 773-6993
Email: info@tuttlepublishing.com
www.tuttlepublishing.com

Japan
Tuttle Publishing
Yaekari Building, 3rd Floor
5-4-12 Ōsaki
Shinagawa-ku
Tokyo 141 0032
Tel: (03) 5437-0171
Fax: (03) 5437-0755
Email: tuttle-sales@gol.com

Asia Pacific
Berkeley Books Pte. Ltd.
130 Joo Seng Road
#06-01/03 Olivine Building
Singapore 368357
Tel: (65) 6280-1330
Fax: (65) 6280-6290
Email: inquiries@periplus.com.sg
www.periplus.com

First edition
08 07 06 05 04 10 9 8 7 6 5 4 3 2 1

Design by Linda Carey
Diagrams by Daniel P. Brennan based on original diagrams by Florence Temko
Photographs by Dave Kutchukian
Printed in Singapore

"Intricate Dragon" on page 26 reprinted from *Chinese Folk Designs* by W. M. Hawley (Dover Publications, New York, 1949).

Contents

INTRODUCTION

Kirigami, the creative art of papercutting, is a surprisingly easy craft that requires only paper, a pair of scissors, and sometimes glue. With these simple means anyone can create greeting cards, calendars, and unusual gift wraps that will be welcome year round.

The word *kirigami* suggests its connection to Japan: *kiri* means "cutting" and *gami* means "paper." For many designs a piece of paper is folded one or more times, with cuts added through all layers. 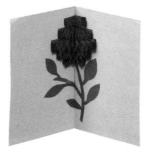 When the paper is unfolded an unexpected symmetric design is revealed. As may be guessed, kirigami is related to origami, the art of folding paper, but many people find it to be easier.

Cutting paper seems to be an instinctive pleasure. At an early age most children like to snip paper into small pieces. Before long they design pictures by pasting the shapes on a background. In *Kirigami Greeting Cards and Gift Wrap* this experience has been expanded for enjoyment by older children as well as adults, who can achieve magic results with just a few cuts.

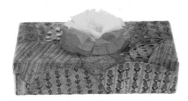

Papercutting is well recognized to provide educational benefits in the areas of art, math, graphic design, and hand-eye coordination. When expanding to spatial relationships, two kinds of symmetry can be observed: line symmetry, which reflects mirror images, and rotational symmetry, which moves around a central point.

You will find step-by-step directions for making birthday and holiday cards, as well as many wonderful ideas for wrapping gifts in unusual ways, all of which can provide many hours of fun for family and friends.

My objective in writing *Kirigami Greeting Cards and Gift Wrap* is to provide projects that are simple to make, though they may look complex, and that will appeal to all ages.

KIRIGAMI QUESTIONS AND ANSWERS

Are origami and kirigami related?

Both words are adaptations from the Japanese that have found their way into the Western vocabulary. In origami a paper square is folded into an object or animal without cutting or gluing. In kirigami paper may be cut and glued, and may sometimes be folded before cutting. Both terms include the Japanese word *gami*, which means "paper"; *ori* means "folding" and *kiri* means "cutting."

I popularized the word kirigami in the English language when I prepared a papercutting kit in 1962. At the time I had been practicing origami and a publisher asked me to write a book about papercutting. When it came to choosing a title, the publishing staff and I sat around debating various possibilities. I 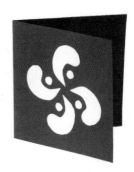 suggested kirigami and we checked with the Japanese consulate to be sure this word would be acceptable. The kit had such a wide distribution that the word kirigami became a common term.

Are special scissors needed?

Any pair of scissors that feels comfortable is suitable for most of the designs in this book, but the sharper the better. If you move on to making intricate paper cuts, you may wish to acquire a pair of small scissors with narrow blades. Because paper contains silicones, which abrade scissors in 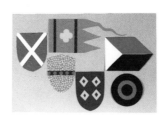 time, it is best to reserve a pair of scissors especially for papercutting, since they may lose the sharpness needed for cutting fabric.

What kinds of papers are suitable?

Almost any kind of paper can be cut successfully. When a paper has to be folded into several layers before cutting, a fairly thin weight is best, but whatever is around the house, including gift wrap, makes for a good start. Colored printing papers are next in line. Tissue paper may be more difficult to handle, but may be useful for certain projects. Origami squares colored brilliantly on the front and white on the back come in packets. Japanese handmade washi papers, decorated with glorious patterns, are sold in squares and larger sheets.

The selection of paper is one of the most important aspects of kirigami. It is appropriate to choose some more unusual papers when it comes to preparing beautiful cards. Most cities now have a paper store with an interesting selection of papers from all over the world. Otherwise catalogs may prove helpful. And do not forget to recycle papers from flyers, magazines, and correspondence.

What are some of the practical uses for kirigami?

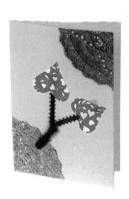

Obviously the title of this book, *Kirigami Greeting Cards and Gift Wrap*, suggests two major applications, but do not overlook using paper cuts in scrapbooking, for holiday room decorations, and for gift tags. Gift tags can be smaller versions of the cutouts chosen for the gift wrapping. Any kind of handmade cards can be sold for raising funds for a good cause.

What about cards and gift wrapping?

The flat surfaces of cards, gift packages, and gift bags lend themselves to applying paper cuts, and are especially useful for mailing. It is a good idea to make a bunch of cutouts for cards or gift wrapping all at one time, ready for future birthdays or holidays.

Nowadays, when what's outside the gift seems almost as important as the gift itself, kirigami ideas can help you create unusual packaging. It may even trump the contents when a recipient treasures one of your cards enough to frame it or keep a box for storing small items.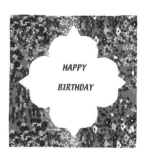

Remember that the selection of beautiful papers will always enhance your efforts and that many designs can be placed either vertically or horizontally as the card or box demands.

Is kirigami educational?

Definitely. Whether in the classroom or art room, working on some of the projects in this book will improve students' graphic design ability, color sense, and visual acuity. Some of the projects are based on geometry and help students visualize math concepts. In social studies students can investigate paper crafts as practiced in different countries.

Studies show that, among other benefits, papercutting improves manual dexterity by 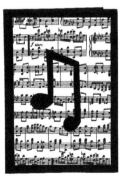 exercising and training small motor muscles, as well as furthering interaction between hand and mind. Most projects in this book are relevant for use in art and math classes. Thus, the technique relates to curriculum requirements. In California papercutting is included in the "Framework for Public Schools, K–12."

At what age can children begin to cut paper?

With the availability of safety scissors, very young children can have fun cutting paper. In fact, it seems a natural outlet that can keep them occupied for long periods of time. Papercutting, like any craft, offers children and adults different challenges for different ages and different stages of development.

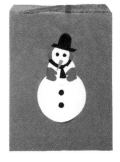

Is papercutting creative?

In a way papercutting is "drawing with scissors," so that taking a pair of scissors in hand invites limitless designing. Some artists who have applied their talents to papercutting have created true works of

art. They may pencil in their design first, or they may work freehand. Since papercutting lends itself well to producing simple, dynamic, or bold images, it has been used in many advertisements and company logos. Some of these are based on Japanese crest cutting.

To explore your own creativity, experiment with one or two paper cuts according to the directions in this book. Then begin to apply variations, which may lead you to entirely new approaches. The projects shown are quite basic, but you can enhance them by decorating them with your own touches of glitter, confetti, paper snips left over from other cuttings, ribbon, yarn, and other odds and ends.

Why add extra framing?

Just as with pictures and photos, framing enhances a composition by adding a finishing touch. To form a frame, glue a rectangular or freeform piece of paper to the card before applying the cut designs inside the frame.

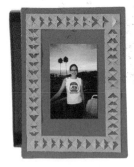

What about tearing paper?

Many cutouts can be torn instead of cut. In that case, paper selection is important. The fibers in machine-made papers are aligned in one direction, which is called grain. The paper will tear more easily with the grain than across the grain. You may have discovered this if you have ever tried to tear out an article from a newspaper. In contrast, handmade papers exhibit no grain direction. They will show nice fuzzy edges when torn, giving a different effect than cut lines.

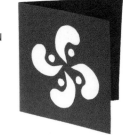

What about copying the designs?

For some projects you may wish to fold the cutting lines exactly. You can copy the diagrams by making photocopies or tracing them. Then place the copy on top of the piece of paper you have selected and cut through all layers. It is alright to copy the designs for your personal use, but not for any commercial purposes.

PAPERCUTTING TECHNIQUES

Diagrams

The following symbols are used:

A line of this thickness shows the outline shape of the paper or existing creases made previously.

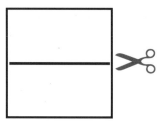

Cut on the heavier lines.

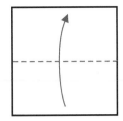

Fold toward you on the broken lines (valley fold).

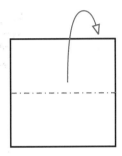

Fold away from you on the broken/dotted lines (mountain fold).

Your paper cuts may not look exactly like the illustrations—scissors have a way of wanting to go their own way and you should let them.

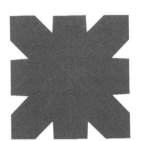

Square Paper

For some of the projects, square pieces of paper are indicated. You can cut any letter-size paper or other rectangle into a square with this simple method:

1. Fold a short edge to a long edge, bisecting a corner.
2. Cut off the extra rectangle.
3. Completed square.

Measurements

Measurements are given in inches and centimeters, but they may not always be exactly equal in order to avoid awkward fractions. In some cases specific sizes are recommended, but in most cases you may use smaller or larger pieces of paper.

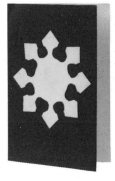

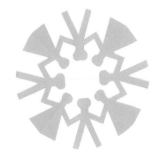

Scissors or Utility Knife?

All patterns can be cut with scissors. Many people, including me, are more comfortable with scissors than with craft knives. If you prefer, you can use a utility knife, which allows for more intricate cutting. Several layers can be cut at the same time by holding the knife like a chisel, straight down. In this case always use a board or a magazine for backing to avoid marring a tabletop or other surface.

How to Cut

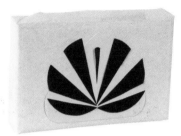

When cutting curves, always hold the hand with the scissors still and move the paper into the scissors. Though it may seem awkward at first, this method will become a habit in a short time and will result in smoother cuts.

Some artisans cut even very intricate designs with the shank of the scissors, which is the part of the blades closest to the handles. This provides better control. So why don't you try it and see how it works for you.

Basic Supplies and Other Materials

The basic supplies for most projects are paper, scissors, and glue. For greeting cards you also need blank cards. All needed supplies are specified at the beginning of each project.

Glue sticks or household glue usually works well, but be sure to apply it thinly. In addition, since white glue dries transparent, it may be applied as a finishing varnish. Paper cement is useful when pieces of paper may have to be repositioned.

You can buy blank greeting cards or make your

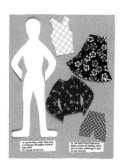

own from card-weight papers, such as construction paper, tag board, cover stock, or manila file folders, poster board, railroad board (slightly lighter in weight than poster board), Canson Mi-Teinte, and handmade papers. These choices offer a wide selection of colors and textures, and may work out to be cheaper than ready-made blank cards.

Pattern Designs

The patterns can be duplicated with freehand drawing, by photocopying, or by tracing. Place photocopies or tracings on the paper you plan to use and cut through both layers.

Multiples

For holiday greetings that you plan to send to many people you may want to duplicate one of your cutouts or copy a design from elsewhere. You can trace or photocopy it or use a computer scanner. You can cut several pieces at the same time, if you use thin paper, but you may find that tissue paper is harder to handle. You can also cut a template from strong paper, such a tag board, which is the same weight as manila folders. Use this pattern to outline your design.

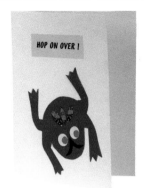

KIRIGAMI PREFOLD

Many people associate the word **kirigami** with paper cut into circular designs, which is a technique closely related to cutting snowflakes. With this method, paper is prefolded into layers, which multiplies any subsequent cuts. The designs that appear when the paper is unfolded always have a strong appeal, because their symmetry pleases our senses. After you have worked on the projects in this book, you may enjoy experimenting with your own designs for greeting cards, invitations, or gift tags.

You need:
A square piece of paper (see page 7)
Pencil
Scissors

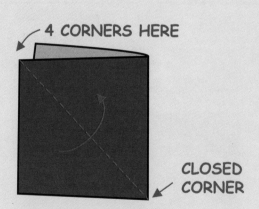

1. Fold the paper into quarters.

2. Look for the closed corner, which is the center of the paper. Fold this corner in half.

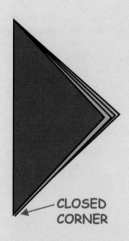

3. Completed Kirigami Prefold.

KIRIGAMI CUTOUTS

These cutouts are all made on kirigami prefolds. They are achieved by cutting sections of paper away from any of the three edges. When you cut on the lines, some areas will fall off. The lines may first be drawn freehand with pencil, traced, or photocopied.

The first cutout is made solely with straight snips. In the second example a simple curved line produces a strong graphic design; the fall-off is used as a frame on a card. Other examples follow.
The triangular prefolds are shown full size to fit a 6" (15 cm) paper square.

After making these cutouts you may be tempted to create your own designs, as you realize that an immense variety is possible with this method simply by cutting away areas from the edges of prefolds.

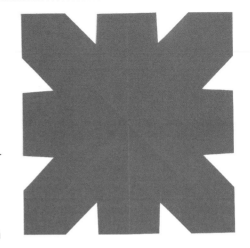

You need:
Paper squares
Pencil and tracing paper, or photocopy
Scissors

CUTOUT WITH STRAIGHT CUTS

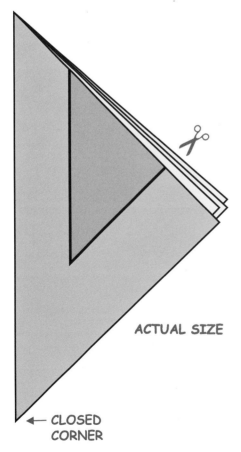

ACTUAL SIZE

← CLOSED CORNER

2. Completed Cutout.

1a. Make a prefold.
1b. Draw, trace, or photocopy the two lines shown.
1c. Cut on the lines. The darker area will fall off.
1d. Unfold the paper.

KIRIGAMI CUTOUTS

TWO FOR THE PRICE OF ONE
A single cut produces two results.

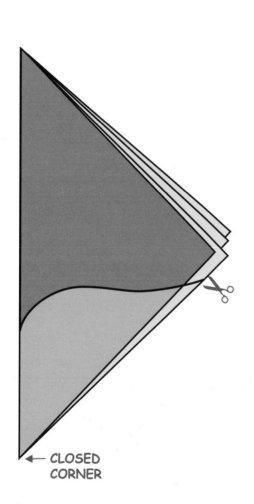

← CLOSED CORNER

1a. On a prefold, draw, trace, or photocopy a curved line and cut on it.
1b. Unfold the two pieces.

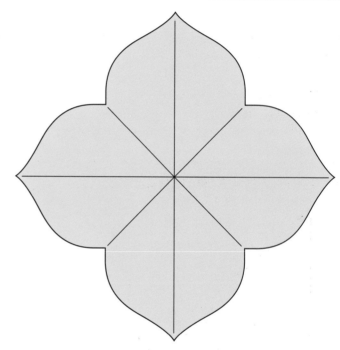

2. You will have an elegant cutout . . .

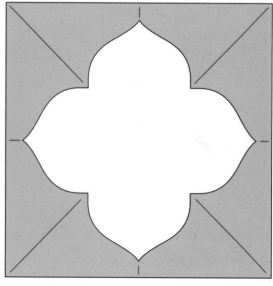

3. . . . and a frame.

KIRIGAMI CUTOUTS

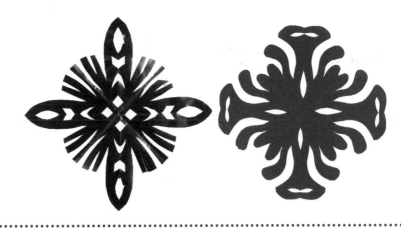

MORE CUTOUTS

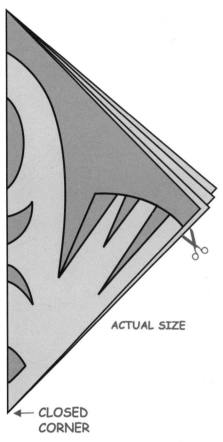

ACTUAL SIZE

← CLOSED CORNER

1. On a prefold, draw, trace or photocopy the pattern shown and cut on it.

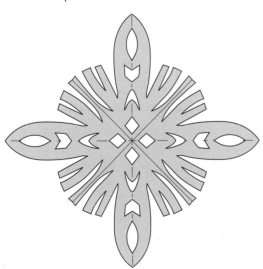

2. Completed cutout.

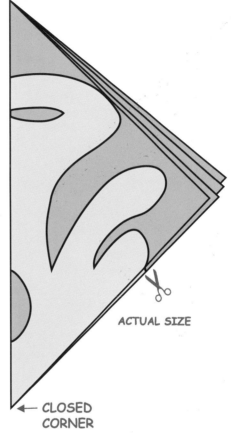

ACTUAL SIZE

← CLOSED CORNER

1. On a prefold, draw, trace or photocopy the pattern shown and cut on it.

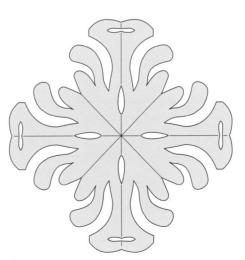

2. Completed cutout.

Caution
Cutouts made on prefolds may fall apart if the center point is not observed or if a cut reaches from one edge all the way across to another edge. After this has happened to you once or twice, you will quickly learn to avoid these pitfalls.

KIRIGAMI CUTOUTS

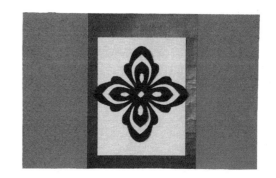

MORE CUTOUTS

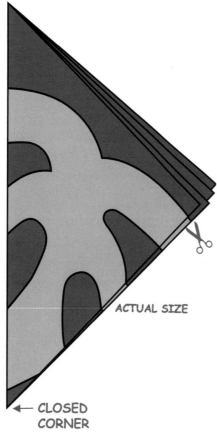

ACTUAL SIZE

← CLOSED
CORNER

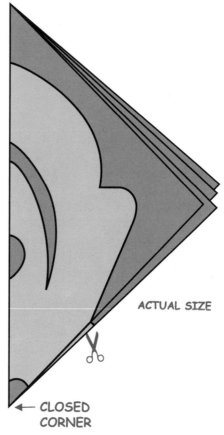

ACTUAL SIZE

← CLOSED
CORNER

1. On a prefold, draw, trace or photocopy
the pattern shown and cut on it.

1. On a prefold, draw, trace or photocopy
the pattern shown and cut on it.

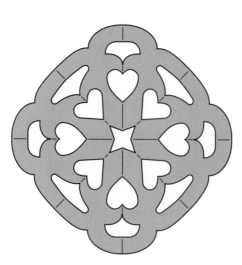

2. Completed cutout.

2. Completed cutout.

COLLAGES

Collage consists of an artistic arrangement made by gluing various pieces of paper on a background. This allows you to make greeting cards in the most creative way, since the shapes can be rearranged until you are pleased with the results. Experiment and play with paper pieces in various colors and textures. Scraps left over from other projects in this book are well suited for collage as are shapes and words cut from magazine pages.

Since collage is such an individual expression, it is demonstrated here with two examples to serve as inspiration rather than with step-by-step directions.

You need:
Paper sheets and scraps
Scissors
Paper Cement
Blank card or gift package

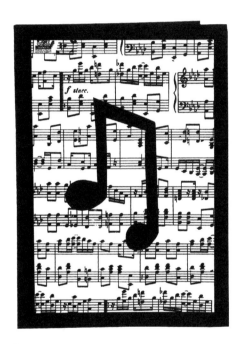

1. This illustration shows a musical card.

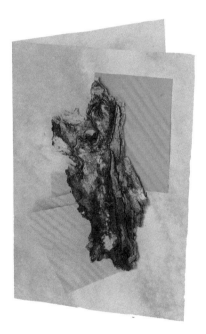

2. This illustration shows three scraps with different textures appliquéd on a card: two pieces of tree bark, and paper corrugated with a paper crimper.

CUT-APARTS

Rectangles, circles, and other simple geometric shapes cut into pieces can present very bold images when glued on greeting cards. Such strong contrasts are termed positive and negative designs. In the first example a circle undergoes this treatment, while the tree that follows expands on the idea.

After you have completed these simple projects, experiment with cutting apart other paper shapes with straight and curved lines. If a result does not please you, toss it out and start again.

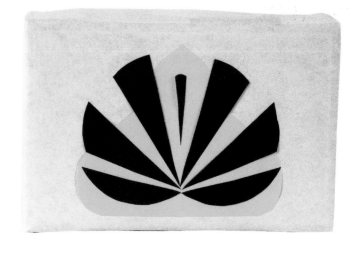

You need:
Colored paper
Blank greeting card, construction paper, or
 wrapped gift
Plate or compass

Pencil
Ruler
Scissors
Glue

CUT-APART CIRCLE

1a. Draw and cut a circle on the colored paper, with the aid of a plate or a compass.
1b. Fold the circle in half.

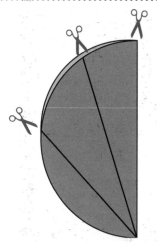

2a. Draw two lines from the curved edge to meet at the bottom of the paper.
2b. Cut on the lines and on the crease.

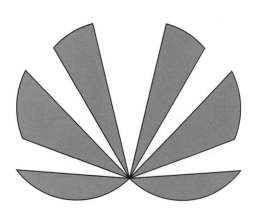

3. Glue the separate pieces on a blank card.

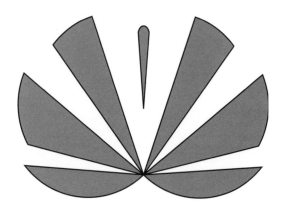

4. Completed Cut-Apart Circle.

CUT-APARTS

CUT-APART TREE

..

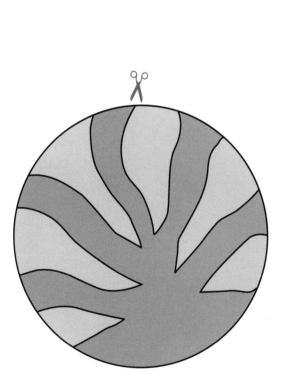

1a. Draw or trace a circle.
1b. Cut it out.
1c. Draw and cut wavy lines on it.

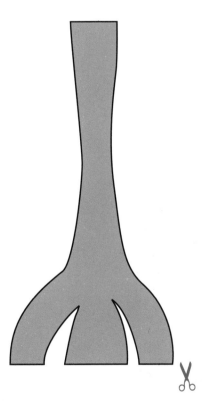

2. Draw and cut a tree trunk.

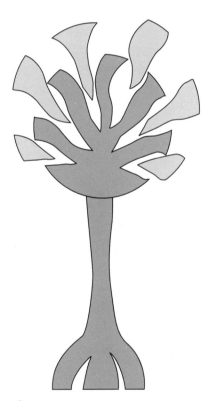

3a. Glue the separate pieces on a blank card or wrapped gift.
3b. Completed Cut-Apart Tree.

DRESS-UP DOLLS

Paper dolls were important toys before the age of television, but they can still provide much creative play. You can become a fashion designer by making your own paper dolls and providing them with several changes of clothing. The doll itself must be made from heavyweight paper or thin cardboard, but all kinds of interesting paper patterns can be used for the clothing. The dolls' clothing can be changed at will when it is attached with rubber cement or glue stick applied lightly.

For a surprise, enclose a set in a plastic envelope and send it as a greeting card or attach it to a gift package.

You need:
Card-weight paper for doll
A variety of papers for the clothing
Pencil and tracing paper, or photocopy
Scissors
Rubber cement

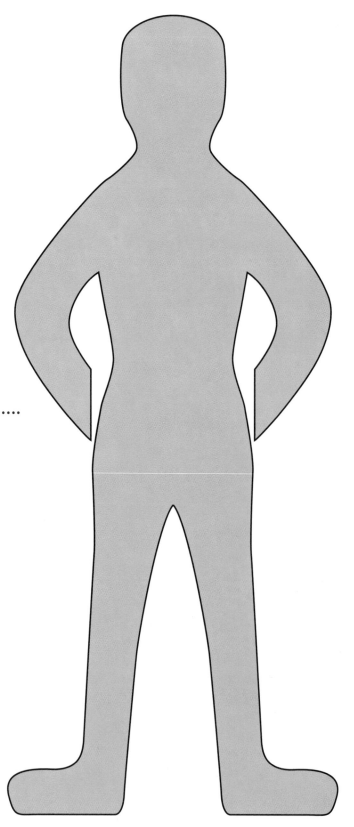

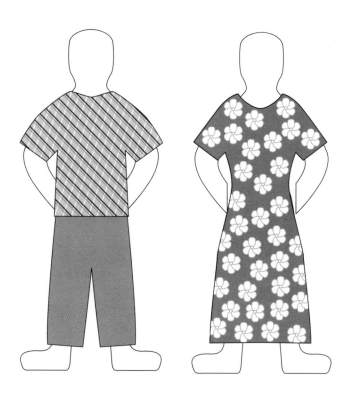

Completed Dress-Up Dolls.

1a. On the heavy paper draw, trace, or photocopy the outline of one or more dolls.
1b. Cut out on the lines.

DRESS-UP DOLLS

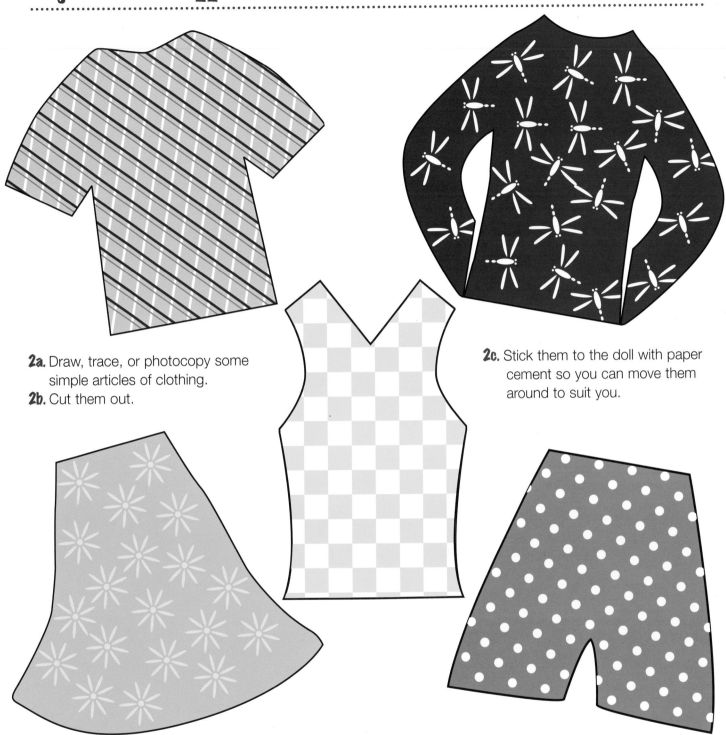

2a. Draw, trace, or photocopy some simple articles of clothing.

2b. Cut them out.

2c. Stick them to the doll with paper cement so you can move them around to suit you.

VARIATIONS

In addition to the basic wardrobe shown, you can create other apparel, hairstyles, shoes, accessories, and whatever else you can think of, perhaps cutting patterns from magazines and catalogs. Imagine styles favored by friends and family members, rock stars, or historical figures.

STANDING DOLL

Glue the top of a strip of heavy paper to the back of the doll, letting the lower end of the strip extend below the feet of the figure. Pull the strip away from the figure at an angle and fold back the extra length at the bottom for a firm stand.

STARS

Many different stars can result from making cuts on the basic kirigami prefold.

You need:
Square paper
Pencil
Scissors

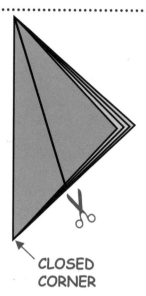

CLOSED CORNER

1a. Make a kirigami prefold.
1b. Make a slanted cut beginning at the closed corner.
1c. You will have two pieces. Unfold the long triangle.

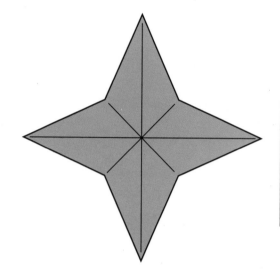

2. Completed Star.

VARIATIONS
Note that any star can become more or less pointed by changing the angle of the cut in step 1b.

LACY STAR

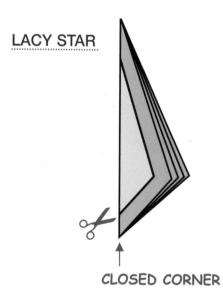

CLOSED CORNER

1a. Cut a star but do not unfold it.
1b. Cut away the lighter area from the long edge.

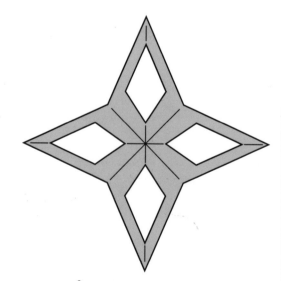

2. Completed Lacy Star.

EIGHT POINTED STAR
For an eight-pointed star, glue two four-pointed stars together.

MON-KIRI JAPANESE CRESTS

The art of cutting family crests has been a custom in Japan for centuries. Distinctive heraldic crests, called mon-kiri, or "crest cuttings," were handed down from one generation to the next and were displayed on the clan's possessions. Crests attached to samurai warriors' clothing and armor made it easy to identify friend or foe in battle.

Many mon-kiri designs are geometric, but also include a variety of plants, animals, clouds, and other forms in nature. Their bold designs have served as the inspiration for many jewelers, clothing designers, and other artisans. Crests first created in paper may later be converted to fabrics and other materials. For the best effect, glue mon-kiri crests on blank cards or gift wrap in strong contrasting colors. The authentic crests shown here may inspire you to design a mon-kiri crest as your own personal signature.

You need:
Paper
Scissors
Glue

PEONY

1. Fold a piece of paper in half.

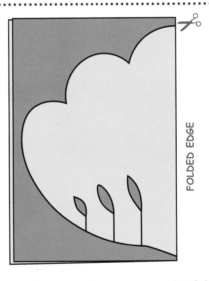

2a. Copy or trace half a peony on the folded edge.
2b. Cut it out through both layers. Note that the interior ovals are reached by cutting slits from the edge. The slits disappear when the peony is glued down.
2c. Unfold the paper.

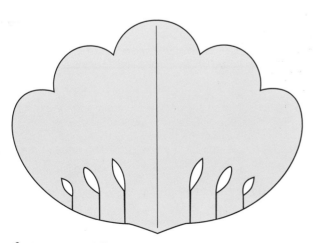

3. Completed Peony.

MON-KIRI JAPANESE CRESTS

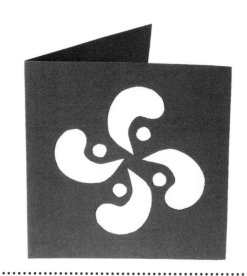

FOUR COMMAS

Use paper that is colored the same on both sides.

1. Fold a piece of paper in quarters.

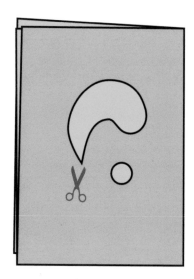

2a. Draw on the comma shape and a round dot as shown.

2b. Cut on the lines through all layers.

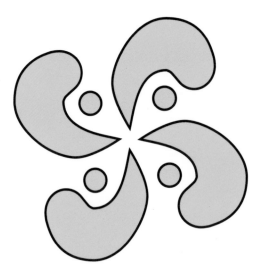

3a. Separate the four layers and arrange them in a circle on a piece of card.

3b. Glue down all cutouts.

3c. Completed Four Commas.

MON-KIRI JAPANESE CRESTS

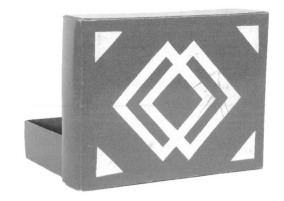

LOCKED SQUARES

You need a 4″ (10 cm) paper square.

1. Fold a square from corner to corner.

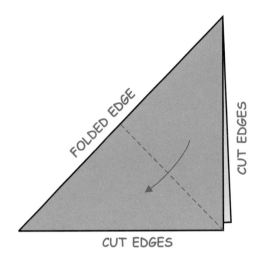

FOLDED EDGE

CUT EDGES

CUT EDGES

2. Fold it in half as shown.

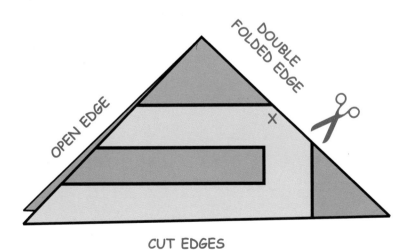

OPEN EDGE

DOUBLE FOLDED EDGE

CUT EDGES

3a. Draw, trace, or photocopy the design on the folded paper in the exact position shown.

3b. Cut out through all layers. Be especially careful at point X, where the square will be held together.

3c. Carefully unfold the paper.

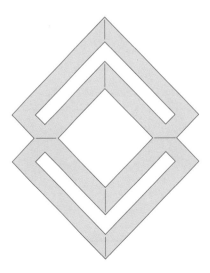

4. Completed Locked Squares.

BOYS AND GIRLS TOGETHER

You can cut a circle of boys and girls dancing together from one piece of paper.

You need:
Paper
Plate or compass
Scissors
Pencil

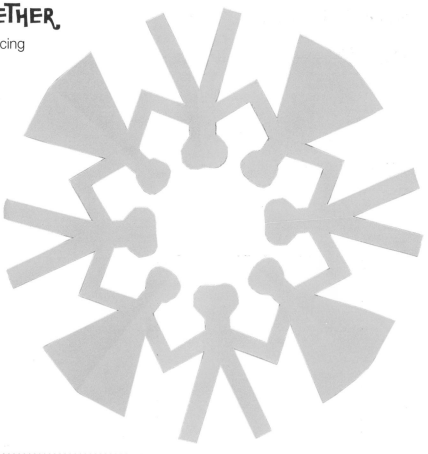

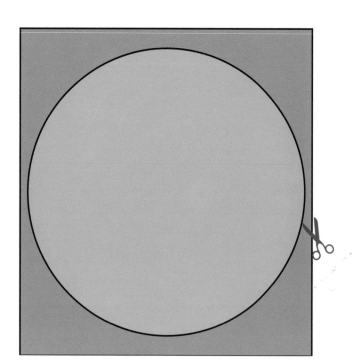

1a. On a piece of paper draw a circle with the aid of a plate or a compass (8" (20 cm) would be a good size).

1b. Cut out the circle.

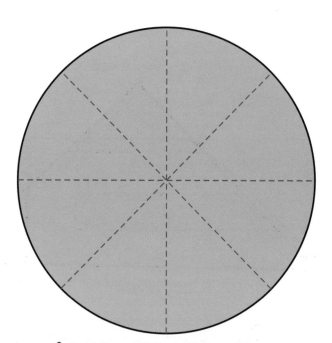

2. Fold the circle in half three times.

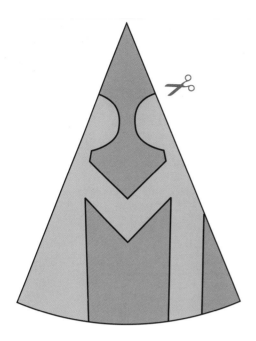

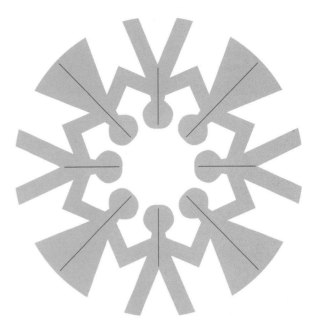

3a. Draw on half a figure of a boy and half a figure of a girl on the edges, as shown.

3b. Cut out the half figures through all layers.

3c. Unfold the paper.

4. Completed Girls and Boys Together.

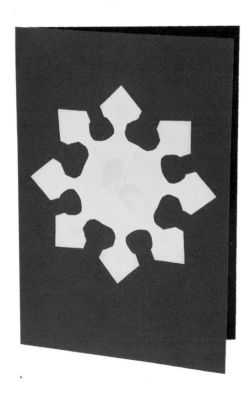

BONUS
You can use the pieces that fell off to decorate greeting cards or report covers.

FLAGS AND SHIELDS

Cutting papers to create flags and shields is a form of collage. They can be inspired by international flags of different countries or states, or they can be wholly imaginary. For fun at a party you can provide colored paper, scissors, and glue and let guests design personal flags and shields. Information about heraldry found in books and on the Internet may serve as inspiration. The designs could be applied to skateboards, surfboards, snowboards, and other equipment or used for decorating large rooms or halls by increasing the size of the patterns.

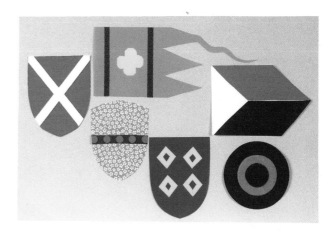

You need:
Paper
Plate or compass
Scissors
Pencil

The shields are cut from paper folded in half. The yellow diamonds are cut through several layers placed on top of one another, illustrating how repetitive designs can be multiplied.

ALPHABET SOUP

Personalize a greeting card or gift by arranging letters of the alphabet in a circular pattern. Cut the initial of the recipient through several layers of paper and you may be surprised at the result. Any letters of the alphabet can be used in this way, as well as any sign of the Zodiac.

You need:
Colored paper
Card-weight paper
Pencil
Scissors
Glue

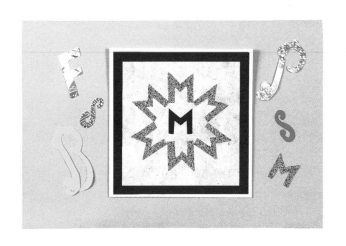

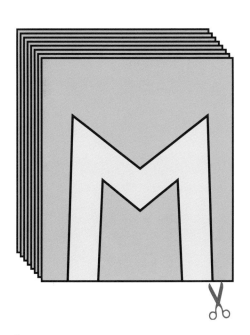

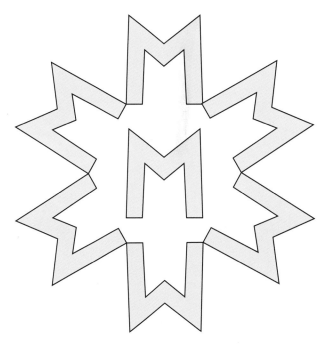

1a. Place eight layers of paper in a pile. If the paper is colored on one side only, then all colors must face up.

1b. Draw the outline of the initial on the top layer.

1c. Cut it out through all layers.

2a. Glue the letters in a circle on card-weight paper.

2b. Completed Alphabet Soup.

DRAGON

The dragon is an example of pictorial papercutting as it has been practiced in China for centuries. Many designs depicting flowers, birds, and scenes from daily life carry deep symbolic meanings. For example, in Asia dragons symbolize strength and goodness and are not considered monsters.

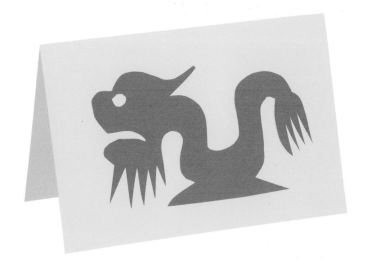

You need:
Red paper
Pencil
Tracing paper or photocopy
Blank card
Scissors
Glue

SIMPLE DRAGON

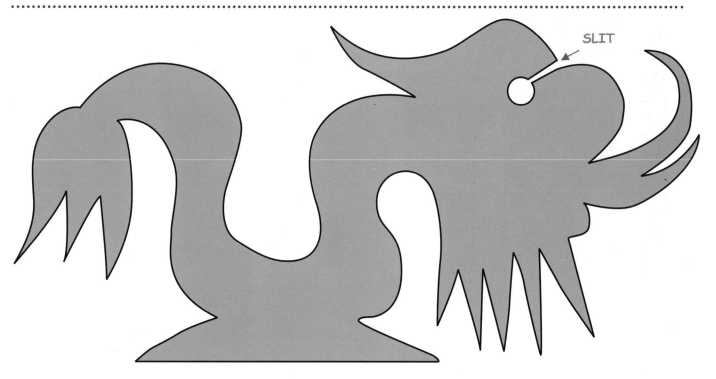

SLIT

1. Copy the dragon, cut it out, and glue it on a blank card. The eye of the dragon is reached from the edge of the paper with a slit that becomes hidden when the dragon is glued down.

INTRICATE DRAGON

Here is an example of an intricate dragon made by a Chinese artisan.

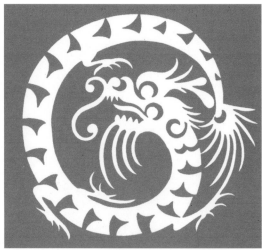

HUMMINGBIRD

Layering several paper cuts on top of one another can lead to very colorful effects, as seen in this long-tailed hummingbird.

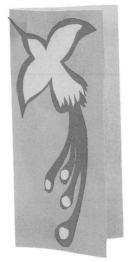

You need:
Colorful papers
Pencil
Tracing paper or photocopy
Scissors
Glue
Blank card

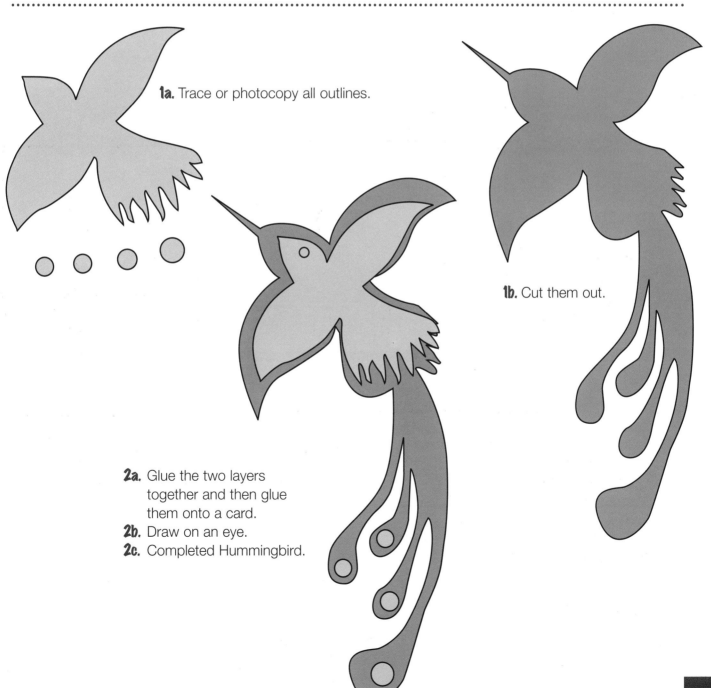

1a. Trace or photocopy all outlines.

1b. Cut them out.

2a. Glue the two layers together and then glue them onto a card.
2b. Draw on an eye.
2c. Completed Hummingbird.

BUNCH OF GRAPES

Composing pictures with torn paper is an old tradition in Japan. In the example shown the grapes and stem were torn from handmade Japanese washi paper. Its long fibers result in softer, fuzzier outlines but other papers may also be used.

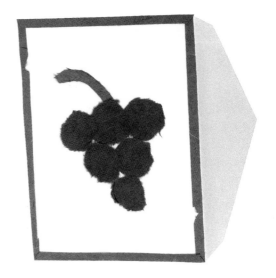

You need:
Purple and brown paper
Ballpoint pen
Coin or small, round, plastic lid
Scissors
Rubber cement
Card or wrapped gift

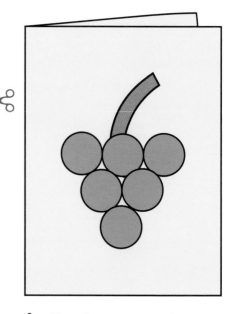

1a. On the purple paper, outline a circle for each grape by drawing with a ballpoint pen around a coin or small lid. Press hard.

1b. Press down around the edges with your thumbnail as you tear out the round pieces. The tear may not follow the circle exactly.

2a. With a ballpoint pen, draw a stem on the brown paper.

2b. Carefully tear out the stem.

3a. Glue the grapes and stem on the background.

3b. Completed Bunch of Grapes.

HOP ON OVER INVITATION

"Hop on Over" is a good message for an invitation but you might also think about sending other messages to a friend on this frog-themed card. For example, the story of "The Notorious Jumping Frog of Calaveras County" by Mark Twain, which is great fun to read, can inspire the theme of your card. Or you could let the classic fairy tale of the Frog Prince move you with a saying such as "Have you been kissed by a frog lately?" or "You have to kiss a few frogs before you find your prince."

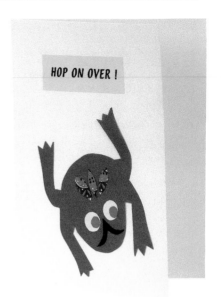

You need:
Green paper
Pencil and tracing paper, or photocopy
Scissors
Glue
Blank card
Paper scraps

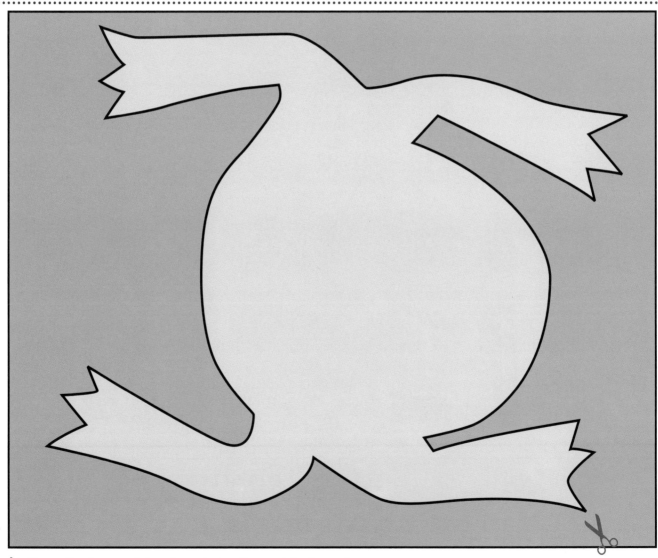

1a. Copy the frog, cut it out, and glue it on a blank card.
1b. Cut out the eyes and other decorations and glue them on.
2. Completed Hop On Over Invitation.

GATE CARDS

These cards, which open from the middle instead of from the side, allow for many variations. The instructions show how to make the basic card, followed by suggestions for enhancing it.

You need:
Card-weight paper, 8 ½" x 11" (or A4)
Scissors
Pencil
Eraser

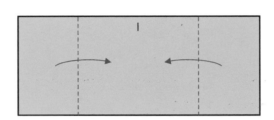

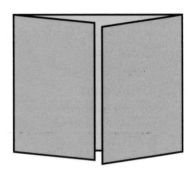

1. Cut the card paper in half lengthwise. Each half will make one card.

2a. Mark the middle of one long edge lightly with pencil.
2b. Fold the two narrow edges to the pencil mark. Erase the mark.

3a. This shows the basic card folded with two equal flaps on the front.
3b. Completed Gate Card.

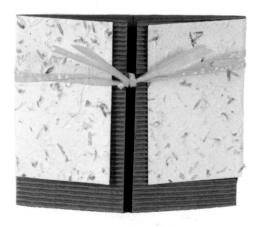

BERIBBONED CARD
This card features handmade textured paper and a ribbon closure. Raffia is attached to the back of the card with tape, brought around, and tied in front. Narrow ribbon may also be used.

CUTOUT DECORATIONS
Gate cards may be designed with mirror images of cutouts glued opposite each other, illustrated with a card made by children in a Chinese school.

FOR YOUR VALENTINE

Most people know how to cut the well-loved shape of a symmetrical heart. Here this simple shape forms the basis for a Valentine's card, which is embellished with a lacy doily and ribbon in imitation of the elaborate handmade Valentines fashionable in the Victorian era of the nineteenth century.

You need:
Red paper
Doily
Two colored paper strips
Blank card
Scissors
Glue

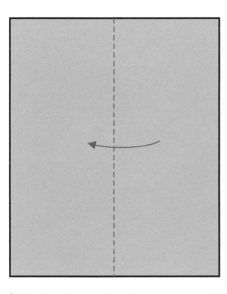

1. Fold a piece of red paper in half.

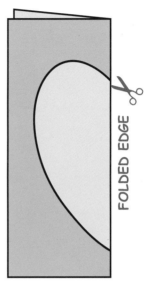

FOLDED EDGE

2a. Draw half a heart against the folded edge.
2b. Cut on the line through both layers of paper and unfold it.

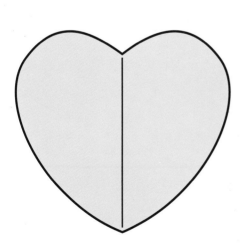

3. Completed Heart.

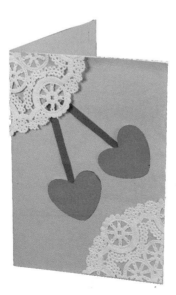

4. Glue two hearts, pieces of the doily, and the paper strips to a blank card, as shown.
4b. Completed Valentine.

VARIATION
After cutting out a heart, cut another smaller one from the same cutout and glue them both down.

ROSES ARE RED

Make this oversize card for that special person in your life. When opened, the card reveals a three-dimensional rose.

You need:
Red tissue paper
Green tissue paper or green marker
Scissors
Glue stick
Cover stock paper, 11″ x 8 ½″ (or A4) or larger, folded in half

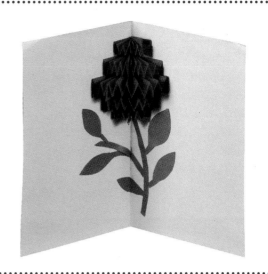

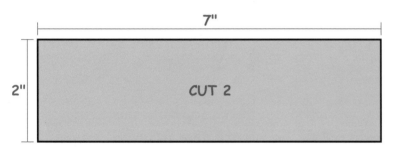

1. Cut two pieces of red tissue paper 2″ x 7″ (5 cm x 18 cm).

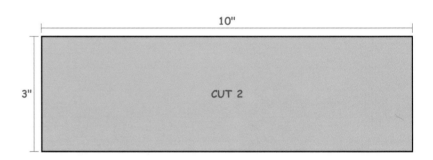

1b. Cut two pieces of red tissue paper 3″ x 10″ (7 cm x 25 cm).

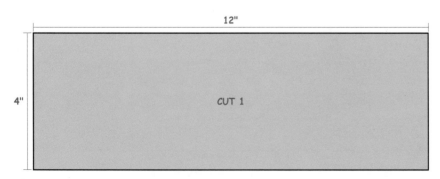

1c. Cut one piece of red tissue paper 4″ x 12″ (10 cm x 30 cm).

ROSES ARE RED

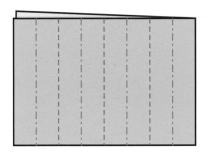

2a. Fold each of the five strips in half four times, parallel to the short edges.

2b. Open the paper and rearrange the creases alternately up and down (mountain and valley folds).

3. Double up each fan and glue two sides together.

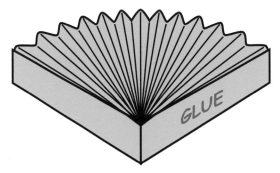

4. Glue all the right sides of the five fans inside the card, close to each other. The middles of the fans sit on the crease of the card.

5. Put glue on the left side of the five fans; then close the card.

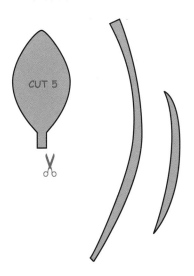

6a. Draw a stem and leaves on green tissue paper and cut them out.

6b. Open the card and glue the stem and leaves below the rose.

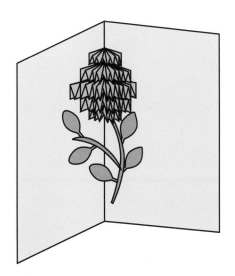

7. Completed Roses Are Red.

ADD A GREETING
You can write your message on the front of the card or inside at the sides of the rose. A patterned piece of gift wrap will enhance the front of the card.

BIRTHDAY POP-UP

Offering a nice surprise when opened, pop-up cards are always memorable. The instructions show how to make the basic mechanism for a birthday or wedding cake. Cardstock is sold in printing shops or craft and art supply shops, but other stiff paper will do.

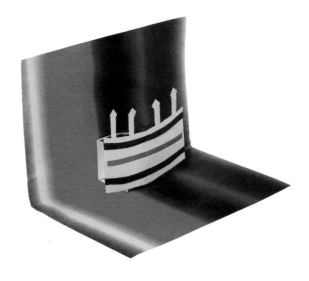

You need:

Colored cardstock, 8 ½″ x 11″ (or A4), for the card
Cardstock in the same color, cut into a strip 1 ½″ x 7″ (4 cm x 16 cm), for inside the card
Cardstock in another color, for the cake cutout
Glue
Scissors
Pencil or pen

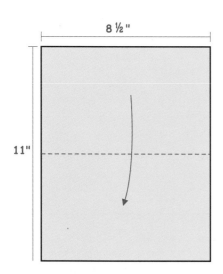

8 ½ "

11"

1. Fold the large piece of paper in half the short way for the outside of the card.

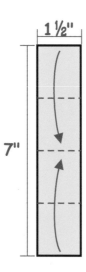

1 ½″

7"

2a. Fold the strip in half and unfold it.
2b. Fold the short edges to the crease you just made.

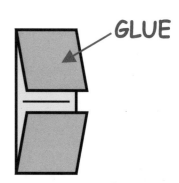

GLUE

3. Put a dab of glue on both end panels of the strip and glue them to the inside of the card.

BIRTHDAY POP-UP

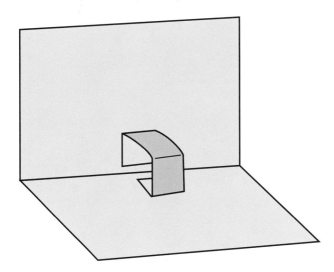

4. Card prepared.

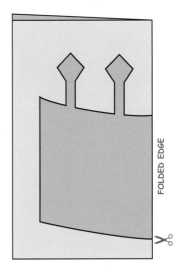

5a. Fold the other colored cardstock in half.
5b. Draw half of a cake on the folded edge and cut it out through both layers.

FOLDED EDGE

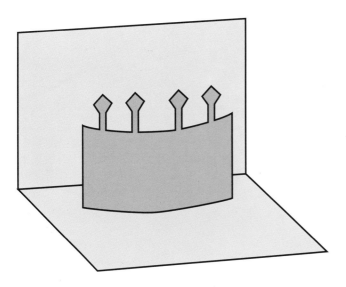

6a. Unfold the cake cutout and paste it to the front of the strip inside the card.
6b. Completed Birthday Pop-Up. Write your message on the front of the card or on any empty space inside.

OTHER THEMES
Instead of a birthday or wedding cake you can substitute a flower, an animal, any other cutout or photo. Always make sure that the paper figure is completely hidden when the card is closed so you don't spoil the surprise.

CHRISTMAS TREE CARD

This simple but effective holiday card can be created in minutes. All members of the family can join in the fun and personalize each card with stars, markers, glitter, and other add-ons.

You need:

Green foil gift wrap or a green paper square, white on the back
Ruler
Pencil
Scissors
Glue
Blank card

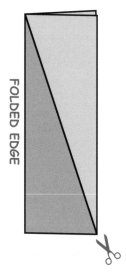

1a. Cut a piece of green paper to measure
3 ½" x 5" (9 cm x 13 cm)
1b. Fold it in half.
1c. Draw a line from corner to corner.
1d. Cut on the line through both layers of paper.

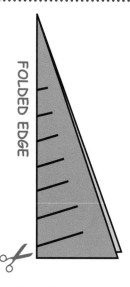

2a. Cut parallel slits at an angle, beginning at the folded edge and ending about ¼" (½ cm) away from the opposite edge.
2b. Open the paper.

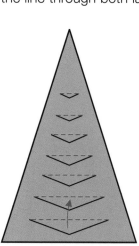

3a. Fold up the angled cuts.
3b. Glue the tree on a blank card.

4. Completed Christmas Tree Card.

Fiesta Card

Make this dramatic card for a special person or a special occasion. As you tear the various layers as shown in the illustration, secure them temporarily with two or three very small dabs of rubber cement. When the arrangement suits you, paste them down with glue stick.

You need:
Printing papers in various colors
Blank card
Gold foil gift wrap
Ballpoint pen
Scissors
Rubber cement or glue stick

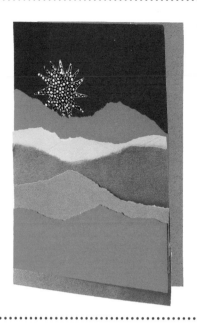

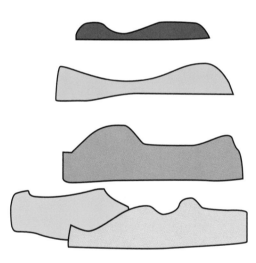

1. Tear pieces of paper into irregular strips, wider than the card.

2. Draw and cut a sun from the gold paper.

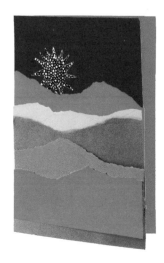

3a. Arrange the strips on the front of the card and glue them down. Since the strips are wider than the card, you have leeway to move them around. Cut any extra off the sides of the card.
3b. Glue on the sun.
3c. Completed Fiesta Card.

POP-UP FOR ANY OCCASION

A surprise is waiting when this card is opened.

You need:
Colored paper
Blank card
Scissors
Glue
Marker or crayons

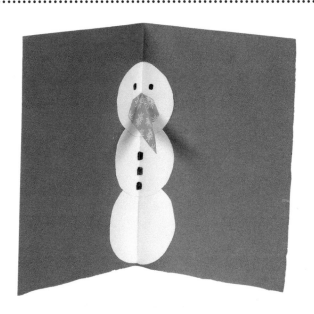

1. Fold a piece of colored paper in half.

FOLDED EDGE

2a. Draw the outline and cut it out through both layers.
2b. Unfold the paper.

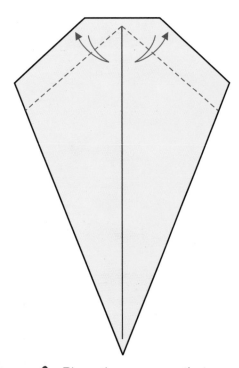

3a. Place the paper so that the crease is up (a mountain fold). Fold the slanted edges to the crease.
3b. Unfold them.

POP-UP FOR ANY OCCASION

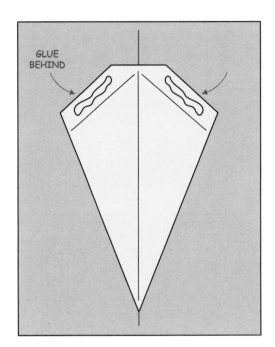

4a. Glue the two areas at the top to the inside of the opened card, placing the long mountain fold on the middle crease of the card.

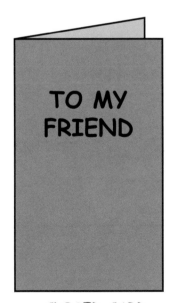

TO MY FRIEND

CLOSED CARD

6. Completed Pop-Up Card. Write the message on the front and on the empty spaces inside.

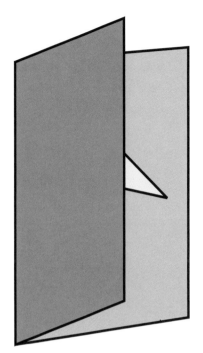

5a. Close the card slowly, while at the same time pulling the pointed corner forward.

5b. When the card is opened nose pops out.

VARIATION

You can turn the pop-up into a face by drawing eyes on both sides of each corner, which will become a nose.

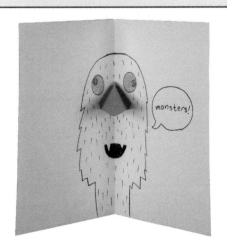

CHRYSANTHEMUM GIFT BOX

This gift box decoration is achieved with just a few pieces of tissue paper.

You need:
Tissue paper in one or more colors
Stapler, or needle and thread
Scissors
Glue
Gift box

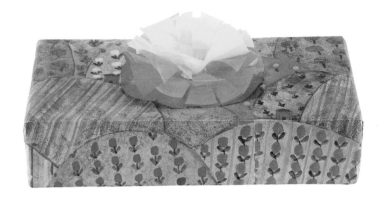

1. Cut six squares of tissue paper with 5″ (15 cm) sides, or larger.

2. Place them on top of one another and staple or sew them together in the center.

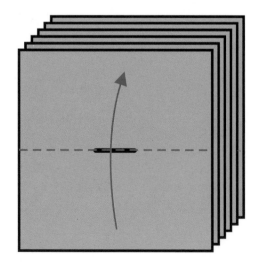

3. Fold the pile in half.

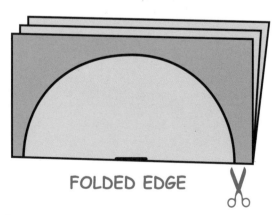

FOLDED EDGE

4. Cut a curve using the folded edge as the base line.

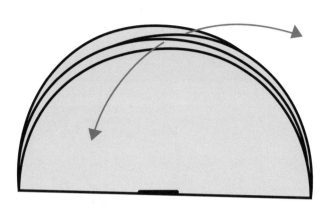

5. Separate the sides evenly to show the staple or sewing.

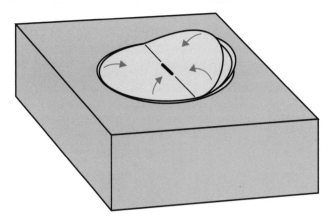

6a. Glue the bottom layer on top of a gift box.

6b. Pull up the top layer and make it stand upright by bunching and pinching it up against the staple or sewing.

6c. Repeat with each layer by pulling the paper gently toward the middle.

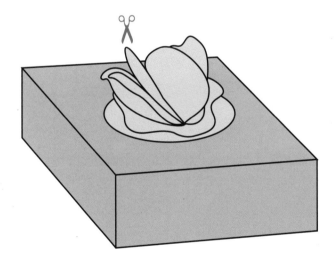

7a. Tweak the flower into a pleasing three-dimensional shape.

7b. From the top, cut snips into the layers.

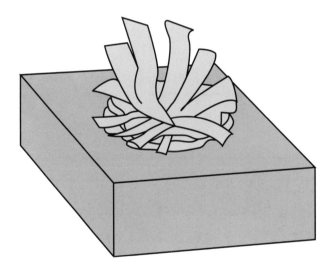

8. Completed Chrysanthemum Gift Box.

BOOK MARK

The complex pattern shown on the bookmark is achieved simply by cutting parallel lines on a folded strip of paper. Patterns will vary, depending on the angle and distance between the cuts made in step 2a. Papers with different colors on the front and the back will produce interesting effects.

You need:

Paper 7″ x 1 ½″ (18 cm x 4 cm)
Cardstock 8″ x 2 ½″ (20 cm x 6 cm)
Scissors
Glue stick

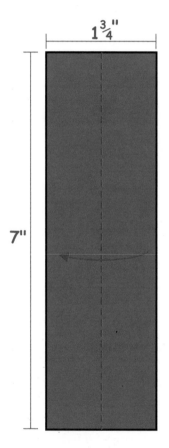

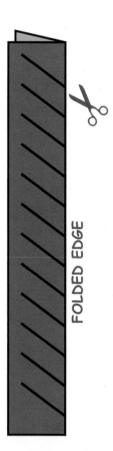

FOLDED EDGE

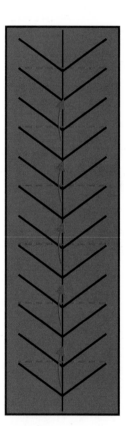

1. Fold the paper strip in half.

2a. Make angled parallel cuts along the whole length of the strip. Begin the cuts on the folded edge, stopping about ¼″ (½ cm) short of the opposite edges.

2b. Unfold the paper carefully.

3a. The middle of the paper is made up of chevron (angled) cuts. Crease up every other chevron.

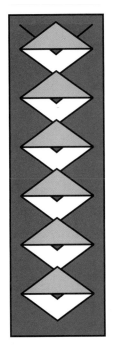

4. Glue the strip to the piece of card.

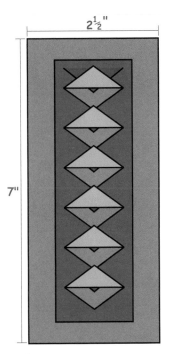

2½"

7"

5. Completed Bookmark.

VARIATION
Punch a hole at the top and knot on a ribbon.

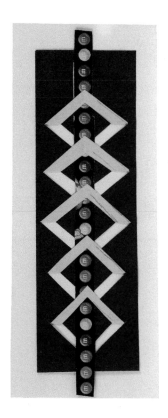

GREETING CARDS AND GIFT BOXES
These bookmarks are equally effective for decorating greeting cards and gift boxes. The framed box shown in the illustration is personalized with a photo.

ADD A STRIP
For the bookmark shown in the photograph cut a narrow strip of paper slightly longer than the bookmark itself. Slide it under the bent-up sections and glue it down.

SNOWMAN GIFT BAG

You can recycle plain paper bags into gift bags by decorating them with cutouts. By relating designs to the special interests of a recipient, you will always show your friendly attention.

You need:

White, black, and red paper
Round lids or compass
Plain paper bag
Scissors
Pencil
Glue

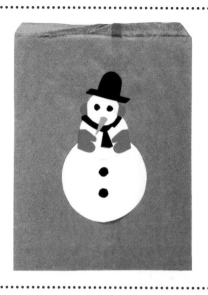

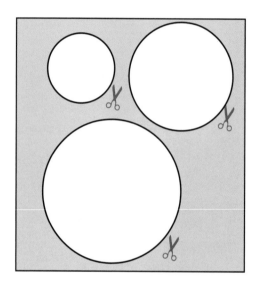

1. From white paper, cut three circles in different sizes with the aid of a compass or round lids.

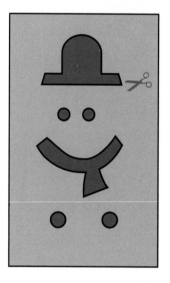

2. From black paper, cut a hat, eyes, scarf, and buttons.

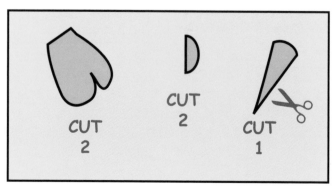

CUT 2

CUT 2

CUT 1

3. From red paper, cut a pair of mittens, ear muffs, and a nose.

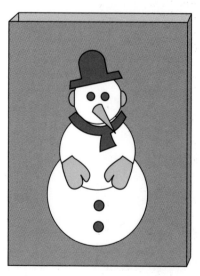

4a. Glue all the pieces on a paper bag.
4b. Completed Snowman Gift Bag.

REMEMBER DAD BOX

Any dad would be proud to receive this handmade box as a gift. The leatherlike effect is produced by covering a box with pieces of masking tape and rubbing it with brown shoe polish.

You need:
Box
Masking tape
Scissors
Shoe polish (solid cream type)
Paper towels
White glue
Small piece of sponge

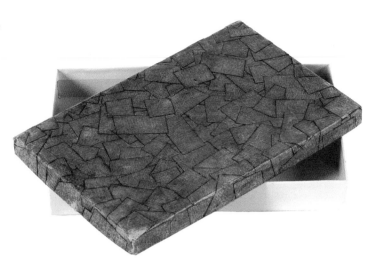

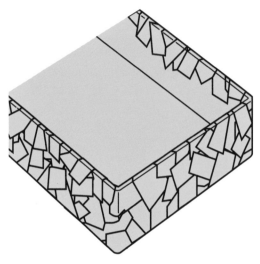

1. Cut a piece of masking tape about 1 ½ ″ (3 cm) square. Adhere it to the lid of the box. Continue covering the lid and sides of the box, cutting more pieces as you go along and overlapping the pieces at random. Tuck the ends of the tape inside the lid.

2a. With paper towels, rub shoe polish all over the lid. The coloring will be darker at the edges of the masking tape, where the polish accumulates.

2b. Clean off any excess polish with paper towels.

2c. Spread glue all over the box lid with a small piece of sponge. Let the box dry completely, until the glue is no longer sticky to the touch and becomes transparent. Repeat with another layer of glue.

3. Completed Remember Dad Box.

Caution
Shoe polish can stain clothing and furniture. Children should be closely supervised by an adult.

ENVELOPES

It is a good idea to size cards to fit into standard envelopes, but you can make your own envelopes in odd sizes or to match the color of a card by following this simple pattern.

You need:
Greeting card
White or colored paper or gift wrap
Pencil
Scissors
Glue

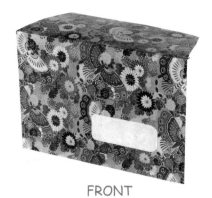

FRONT

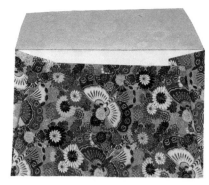

BACK

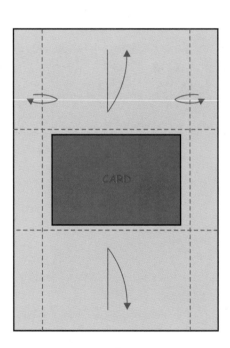

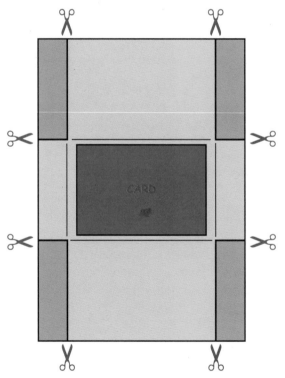

1a. Cut the paper three times the smaller side of the card. Add extra along the sides, as shown.

1b. Place the card on the paper chosen for the envelope.

1c. Fold and unfold the four edges over the card, leaving some leeway each time.

2. Cut away the areas at the four corners as shown by the shading in the diagram.

ENVELOPES

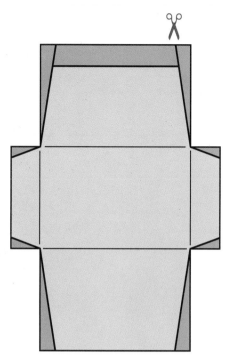

3. Angle the edges by cutting away the darker areas.

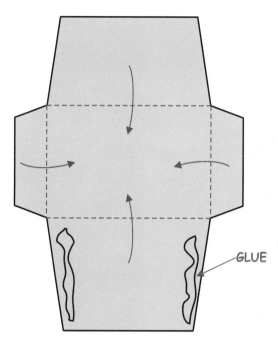

4a. Fold in the short edges on existing creases.
4b. Spread glue along the sides of the longer bottom flap and fold up the flap.
4c. Fold down the top flap.

GLUE

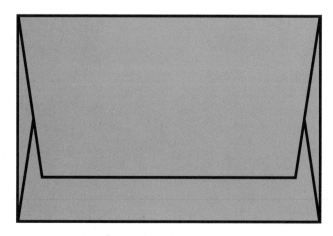

5. Completed Envelope. Seal it with glue, tape, or a round seal.

ACKNOWLEDGMENTS

A big and heartfelt thank you to family

members, friends, and neighbors for their support throughout the

writing of *Kirigami Greeting Cards and Gift Wrap*. Special appreciation to Jackie

Booth, who lent her "eye"; to Cath Kachur and John Andrison, who were always

ready with pertinent suggestions; and to others who tested the instructions to help

provide clarity. The Fiesta Card was inspired by an invitation from the

Mingei International Museum, San Diego.

Since the craft field is a continuum, I am indebted to the age-old

traditions from many parts of the world

on which some of my ideas and

designs are based.